Watteau

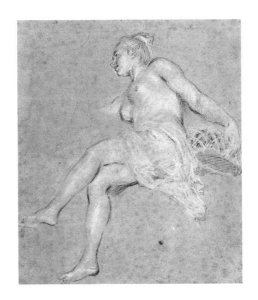

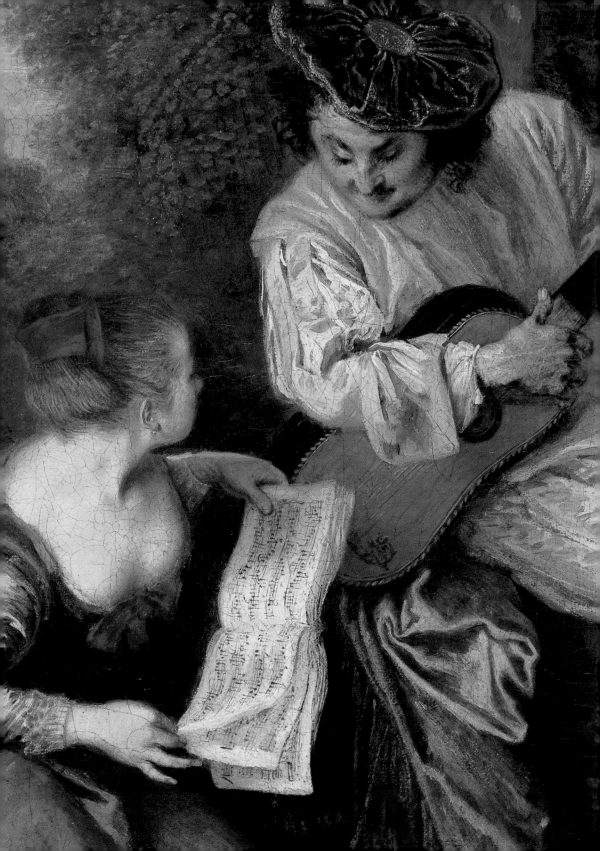

GREAT ARTISTS

Watteau

HUMPHREY WINE

SCALA BOOKS

First published 1992
by Scala Publications Limited
3 Greek Street
London W1V 6NX

in association with
Réunion des Musées Nationaux
49 Rue Etienne Marcel
Paris 75039

Distributed in the USA and Canada by
Rizzoli International Publications, Inc
300 Park Avenue South
New York
NY 10010

ISBN 1 85759 000 7

Designed by Roger Davies
Edited by Paul Holberton
Produced by Scala Publications Ltd
Filmset by August Filmsetting,
St Helens, England
Printed and bound in Italy by
Graphicom, Vicenza

Photo credits: Bridgeman 36; London,
British Museum 3, 5, 13, 15, 26;
© RMN 6, 8, 9, 10, 11, 12, 21, 24, 29,
30, 32, 33, 37

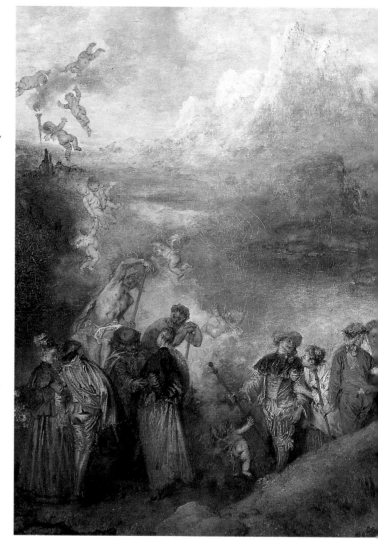

FRONTISPIECE **29** Jean-Antoine
Watteau, Study for *Flora*

TITLEPAGE Detail and whole of
1 Jean-Antoine Watteau, *La Gamme
d'amour* (The range of love)
Oil on canvas, 50 × 59.7 cm
London, National Gallery

THIS PAGE **21** Jean-Antoine Watteau,
Le Pèlerinage à l'Isle de Cithére

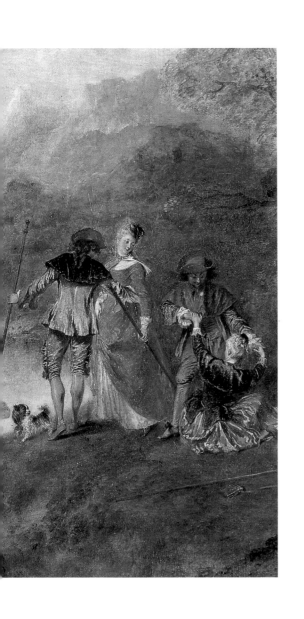

Contents

The early years

3 After Watteau
Self-Portrait
Engraving by L. Crépy
The painting is lost. In its pose and use of a theatrical collar it is like a self-portrait by his former mentor Gillot, but here Watteau shows himself as an independent maker of theater paintings. That, and his apparent age, suggest a date around 1712 when Watteau was provisionally admitted to the Academy.

2 Jean-Antoine Watteau
L'Ecureuse de cuivre (The saucepan cleaner),
Oil on canvas 53 × 44 cm
Strasbourg, Musée des Beaux-Arts
This early work by Watteau obviously demonstrates his debt to Dutch art. It is a version of an established kind of Dutch low-life genre painting. But the informality of the subject matter masks the formality of the construction. On a pattern of horizontal and vertical lines are superimposed diagonals linking the figures.

For a painter of his importance the hard facts on Watteau's life and art are miserably few. Even the titles of most of his paintings derive from prints made some ten years after his death. It is necessary to admit that within the voluminous literature on Watteau, much has had to be a series of educated guesses, and at worst a projection of the author's fantasies. In trying to avoid the latter, we shall start at least with some documented facts.

On October 10, 1684 Watteau was baptized Jean-Antoine in the parish of St. Jacques in Valenciennes. His father was a violent man, although there is no record that he was violent toward Antoine or his three brothers. The family business was roof tiling. Since Watteau's father, Philippe, worked for the municipality of Valenciennes, we can assume that his family was reasonably prosperous. Watteau's godfather, Jean-Antoine Bouche, was in charge of the town's masonry. In an age when building, decoration, and the fine arts were more closely connected than today, the local painters would have been known to the family.

What of the town of Valenciennes? It had been part of Flanders until six years before Watteau's birth when it was captured by the armies of Louis XIV in an aggressive campaign to extend France's northern border. The economic and artistic capital of Flanders was Antwerp, and earlier in the seventeenth century the dominant artistic personality had been Rubens. Watteau never visited Antwerp, but, as will be seen, Rubens in particular and Northern art in general would significantly influence Watteau's subject matter.

According to one of his early biographers, his friend Jean de Jullienne, Watteau was ten or eleven years old when he was apprenticed to a Valenciennes painter. This was a normal age to start learning a career. Why painting

should have been chosen is not known, nor is the name of his master. It may have been Antoine Pater, the Valenciennes sculptor and father of Watteau's only recorded pupil, Jean-Baptiste Pater. But since Jean-Baptiste was still alive when Watteau's unnamed master was dismissed as "mediocre" in accounts of Watteau's life, it is more likely to have been one Jacques-Albert Gerin, particularly because the date of the latter's death, 1702, coincides with the generally accepted date of Watteau's arrival in Paris.

What motivated Watteau to go to Paris can only be guessed at. Some of his early biographers say it was in order to improve himself as a painter; others claim that he was taken there by a theater decorator engaged by the Opéra de Paris. What is known, however, is that around 1700 there was an economic crisis in Valenciennes and consequently a mass exodus of the male population. Furthermore, the local painters' guild was conservative and so unlikely to assist an apprentice who was not from a guild family. In other words, whatever the uncertainties of a young painter's life in Paris, they must have seemed more exciting uncertainties than those of Valenciennes.

Watteau's first years in Paris

4 Jean-Antoine Watteau
L'Indiscret (Spinner and flute player)
Oil on canvas, 55 × 66 cm
Rotterdam, Boymans-van Beuningen Museum

Watteau's painting is based on Rembrandt's etching of *The flute player* (5). The spindle as well as the flute would have been understood as symbolic of the penis. The painting probably dates from around 1715, and was engraved after Watteau's death by Michel Aubert. Watteau later re-used the head of the flute player in his *Sous un Habit de Mezzetin* (18).

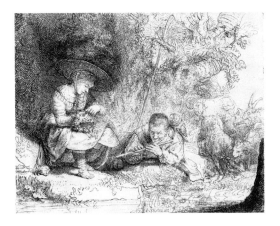

5 Rembrandt van Rijn
The flute player, c1640
Etching

Watteau did not borrow all of Rembrandt's erotic imagery. He suppressed the goats, symbols of lust, quenching their thirst, as well as the garland of flowers, equivalent to the vagina. Watteau's spinner is, however, more overtly encouraging to her male companion than is Rembrandt's shepherdess.

A
ll early accounts are in agreement that soon after arriving in Paris Watteau worked for a picture dealer on the Pont Notre-Dame. In those days there were numerous shops on the bridge, many occupied by picture dealers and print sellers. Watteau's time was spent churning out small religious paintings and copies of genre pictures. Tedious as this may have been, it was an unrivalled opportunity for Watteau to study and copy prints after, and paintings of, the *petits maîtres* of Flanders and the Netherlands.

In one sense the influence of his study was limited. The number of scenes of everyday life which Watteau painted are few and are largely concentrated in the early part of his Paris career. An example is Watteau's *Ecureuse de cuivres* (Saucepan cleaner) (**2**) of 1709–10, the subject matter of which is close to a *Kitchen interior* (now in Aix-la-Chapelle) by Willem Kalf (1619–1693), a Dutch artist who had worked in Paris from 1642 to 1646 and whose works were well known there.

In a wider sense, however, a Northern approach to art was fundamental to Watteau. Visual jokes and ambiguities were characteristic of Watteau's work and possibly had their origin in his study of Dutch and Flemish art. This is clearly seen in his *L'Indiscret* (**4**), which derives its theme and the broad outlines of its composition from Rembrandt's etching, *The flute player* (**5**). In both images the flute, which points between the women's legs, is a visual pun. Although such explicit reference to the sexual act is rare in Watteau's surviving work, the kind of visual punning common in Dutch seventeenth-century genre scenes is not.

There is another fundamental Northern characteristic to Watteau's art beyond any

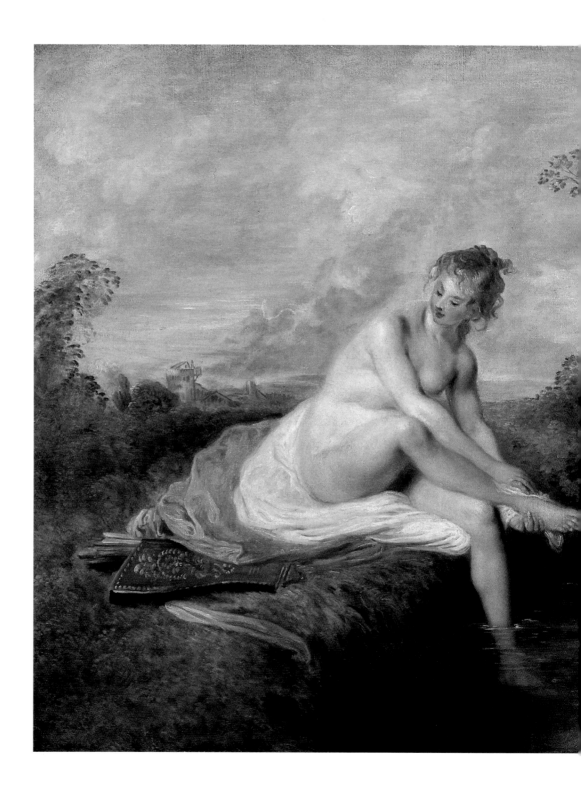

direct borrowing of motif or subject matter. Rarely did he idealize his figures. On the contrary, in his so called *Diane au bain* (**6**), he borrowed a figure from a painting of *Diana and her companions* (now in Tours) executed in 1707 by Louis de Boullongne, and gave her a face not remotely classical and hair casually tied in a top-knot. His use of drawings was also non-academic. Unlike more academically trained artists, he did not usually make compositional drawings with specific paintings in mind. Rather he drew studies of single figures in a bound sketchbook, and when he started to paint, he would turn to this to choose and combine the studies that best suited his purpose. A figure study might therefore be used more than once, and sometimes many years after it was made. For example, the man standing holding a musket in *Le Rendezvous de chasse* of *c*1720 (**7**) is derived from a drawing of some eight years earlier. His frequent use of a single sheet of sketched studies can be illustrated by a drawing in the Louvre (**8**). The figure on the left was used in *Les Charmes de la vie* (**17**) and, with minor changes, in the painting *Arlequin, Pierrot and Scapin* (now known only through an engraving). The central figure, again slightly changed, appears in *La Proposition embarrassante* (Hermitage, St Petersburg). That

6 Jean-Antoine Watteau
Diane au bain (Diana bathing)
Oil on canvas 80 × 101 cm
Paris, Louvre
Like most of Watteau's paintings, the date of this work is unknown and suggestions have varied from 1713 to 1718. The motif of a nude female drying her foot was not uncommon in sixteenth- and seventeenth-century art. By adding the quiver and arrows Watteau has turned his nude into the goddess Diana. However, there is no vestige of her story or myth, and Watteau's lascivious figure has few other characteristics of the goddess.

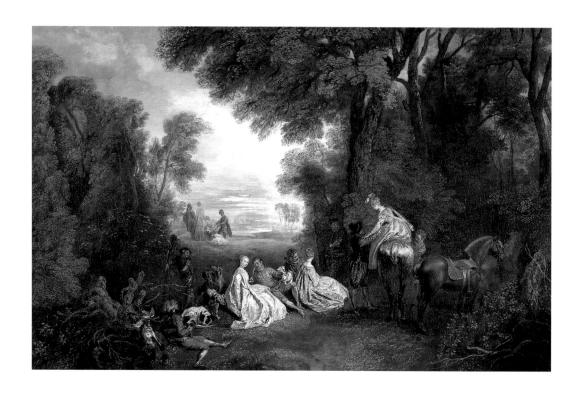

7　Jean-Antoine Watteau
Le Rendezvous de chasse (Meeting for a hunt)
Oil on canvas, 124 × 189 cm
London, Wallace Collection

The hunter at the left, and especially the horse at the right, are painted more solidly than the other figures, as if Watteau were using technique as well as costume to distinguish the contemporary world from that of fantasy. The lady dismounting and the man helping her are taken from a print by Jacques Callot.

Detail of 7

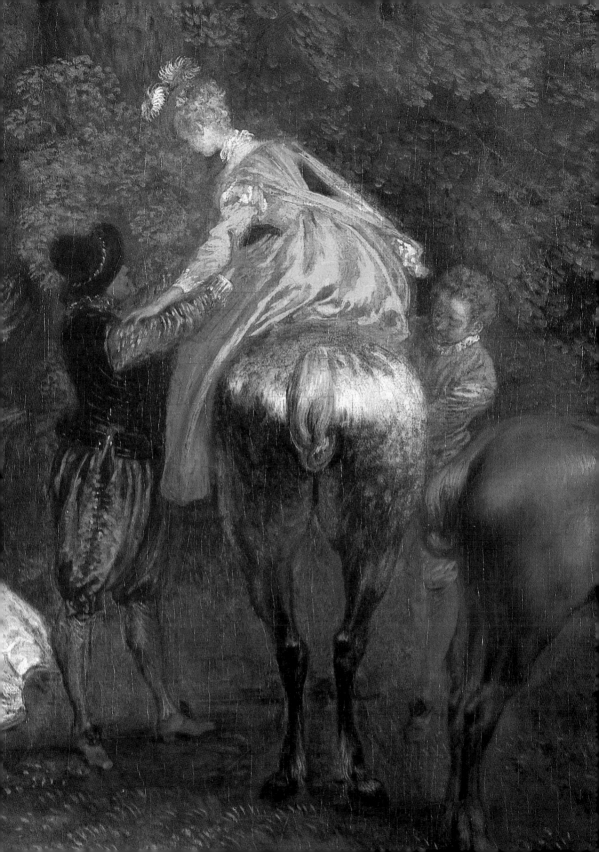

on the right was used in *Amusements champêtres* (private collection) and in reverse for *Leçon d'amour* (Nationalmuseum, Stockholm).

The non-academic nature of Watteau's practice is not, however, attributable solely to Northern influences. There were other elements in his formative years in Paris. He was a relatively late starter at the Paris Academy of Painting and Sculpture where there is no record of him before 1709, the year he would have reached the age of 25. Admittedly he then won the second prize in the Academy's annual painting competition (for a biblical subject), which suggests some prior attendance as a student. Equally pertinent, however, was the kind of paid work he did after leaving the shop on the Pont Notre-Dame. It was probably around 1705 that Watteau started to work for Claude Gillot (1673–1722). Gillot was best known for his comic theater scenes, including subjects from the Commedia dell'Arte (**9**). The Italian comedians had been expelled from Paris in 1697 because of the scurrilous nature of their plays, but their stock characters such as Harlequin and Colombine were taken up by other actors who improvised plays at the Paris fairs. These were often satirical and smutty. Additionally they contravened the monopoly of the Opéra and the Comédie-Française. Such plays were not within the traditional repertoire from which history painters took their subjects, although

8 Jean-Antoine Watteau
Three studies of a seated woman
Black, white and red chalk and pencil on beige paper,
22.6 × 29.3 cm
Paris, Louvre

This is probably of the period 1716–17. Such studies were fundamental to Watteau's painting, and were soon prized by eighteenth-century connoisseurs almost equally. They convey effectively a sense both of movement and of texture.

9 Claude Gillot
Scene from the Commedia dell'Arte
Drawing, ink and brown-red wash, 16.8 × 21.5 cm
Paris, Louvre
The debt that Watteau's early drawing style owed to Gillot can be clearly seen: both artists' figures are still with curiously tapering legs, and facial features are similarly constructed.

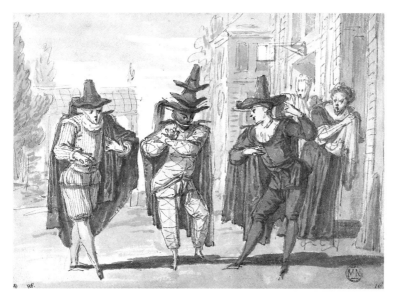

they became an inseparable element of Watteau's material.

For the two or three years that Watteau worked for Gillot, his style was profoundly influenced by that of the older man. Indeed, within a few years of Watteau's death there was confusion in the attribution of their respective works, a confusion not entirely resolved today. The indebtedness to Gillot's graphic style is shown in the elongated, stiff figures of Watteau's early red chalk drawing in the Louvre of *A draper's shop* (**10**). Watteau's *Arlequin, empereur dans la lune* (**12**) has often been attributed to Gillot but is now usually recognized as a work of Watteau. A comparison with Gillot's *Les deux Carosses* (**11**) shows similar, somewhat stiff figures and a composition extending across the picture plane. The subject of Watteau's painting is a scene from a three-act comedy by Nolant de Fatouville

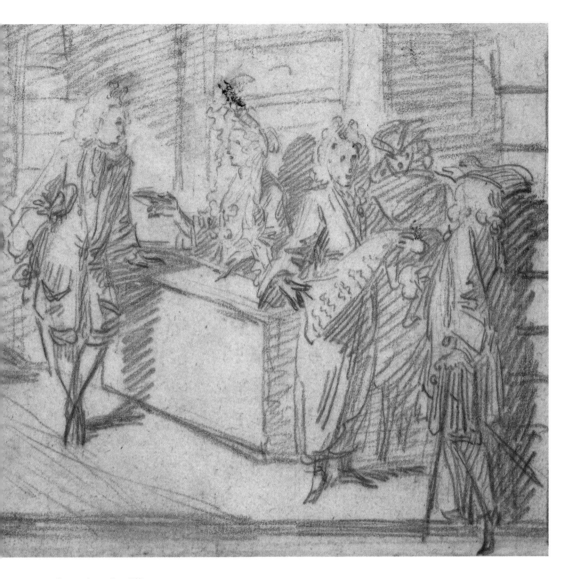

10 Jean-Antoine Watteau
A draper's shop
Drawing, red chalk, 15.2 × 22.1 cm
Paris, Louvre

One of the artist's earliest known drawings, probably dating from 1705–06, this was possibly used, or recalled, by Watteau when he came to paint *L'Enseigne de Gersaint* (36) in 1720. Painting shop-signs was considered mundane work, but Watteau and Chardin were among the artists who used shop-signs to advertise their talent.

called *Arlequin, empereur dans la Lune*, written in 1684. It was probably its performance of September 1707 at the Foire St. Laurent that inspired Watteau's painting.

Although some early biographers talk of a falling out between the two men, it was possibly the tedium of precisely depicting specific moments from specific plays which prompted Watteau to leave Gillot around 1708 and to seek work more likely to provide an outlet for his creative imagination. In any event, it was apparently Gillot who introduced Watteau to Claude III Audran (1658–1734). Audran was a leading painter of interior ornamentation and specialized in arabesque patterning. Audran's practice was to design an ornamental frame-

11 Claude Gillot
Les deux carosses **(The two sedans)**
Oil on canvas, 127 × 160 cm
Paris, Louvre

The emphasis on gesture and expression allies Gillot's painting to academically inspired history painting. After he left Gillot, the gestures and expressions of Watteau's figures became far more restrained. Often, when they are not shown facing away or *profil perdu*, their thoughts seem inwardly directed.

12 Jean-Antoine Watteau
Arlequin, empereur dans la lune (Harlequin,
Emperor on the moon)
Oil on canvas, 65 × 82 cm
Nantes, Musée des Beaux-Arts

This was probably painted towards the end of
1707 after a design by Claude Gillot now
known through a print. Mezzetin, the figure at
the extreme left of the painting, was to
reappear in a different costume in the painting
of the same name, now in the Metropolitan
Museum, New York, executed *c*1718.

work and to employ specialist painters to fill
in the spaces with scenes or objects of the
client's choice. Probably Watteau was
employed as a painter of theater scenes. His
success as a decorator can be measured first by
the statement of his friend, Gersaint, who
asserted that Audran often left Watteau free
to compose the overall design as well as the
filling, and secondly by the range of projects
which Watteau undertook.

The vogue for painted arabesques on wall
panelling had been started many years pre-
viously by the painter Simon Vouet
(1590–1649), whose designs of 1643 at the
Palais Royal, Paris, had been disseminated by
prints made after them. The art form's essence

was a playful inventiveness of design, which around 1700 was generally lighter, more streamlined, with more of the field left free. Watteau contributed to these trends, as shown by two surviving panels from his decoration of the Hôtel de Nointel, Paris, of c1707–08. However, most of Watteau's decorative panels have been destroyed as a result of changes of taste and so are known only through prints. One such called *L'Escarpolette* of c1713–14 (**13**) shows both his lightness of touch and the subtle ambiguities he created in the depiction of space.

By 1713–14, Watteau had become an independent master. Certainly a substantial part of his income must have been derived from work of this nature: indeed, when the young Swedish collector, Carl Gustav Tessin (1695–1770), visited him in June 1715, he referred to Watteau primarily as a painter of decorative schemes. Watteau also helped to popularize forms of decoration called *singerie*, in which monkeys are playfully costumed, and *chinoiserie*. The latter he employed in designing panels for the Cabinet du Roi at Château de la Muette. Besides being lucrative, Watteau's introduction to Audran was important to his artistic development. First, it gave him the opportunity to create rather than merely copy. Secondly, Audran was curator of the Luxembourg Palace in Paris which then housed Rubens's celebrated Medici cycle of paintings. These Watteau took the opportunity to study, as he acknowledged in numerous later borrowings for his own paintings.

Watteau's art had, however, also been developing in other directions. In 1709 he returned briefly to Valenciennes. It was from around this time that he started to paint a number of scenes of military life (**14**). Indeed the sale of one of these scenes to the print-dealer Pierre Sirois (1655–1726) financed his journey. The War of the Spanish Succession

13 After Watteau
L'Escarpolette (The swing)
Engraving by L. Crépy
The goat, the swing, the bagpipes, the basket, and the hat were all erotic motifs which Watteau has incorporated into a playfully sophisticated design.

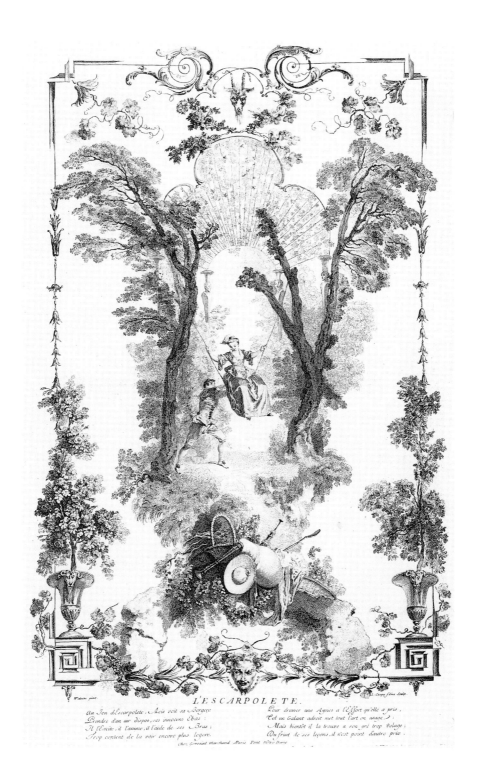

L'ESCARPOLETE.

Au Jeu d'l'escarpolete, Acis voit sa Bergere
Prendre d'un air ingeno, ses innocens Ebats;
Il s'Excite, il l'anime, il l'aide de ses Bras;
Trop content de la voir encore plus legere.

Pour dresser une Agnes a l'Effort qu'elle a pris,
Tel un Galant adroit met tout l'art en usage;
Mais bientôt il la trouve a son gré trop volage;
Du fruit de ses leçons, il n'est point d'autre prix.

Chez Gersaint Marchand a Paris Pont Nôtre Dame.

21

(1701–13) was having a depressing effect. The French lost the battle of Malplaquet, near Valenciennes, in September 1709, and a widespread famine followed that winter. Watteau's paintings with soldiers resting, smoking, talking to girls, some soldiers wounded and others bored, can be seen as parodies of van der Meulen's celebratory depictions of Louis XIV's conquests of the previous generation. The monotony and lassitude that Watteau depicted in his military scenes quite possibly reflected the mood of a substantial section of French urban society who were tired of the war.

14 Jean-Antoine Watteau
L'Alte (Soldiers in camp)
Oil on canvas, 32 × 42.5 cm
Lugano, Thyssen-Bornemisza Collection

This is generally thought to have been painted around 1709–10. Valenciennes, where Watteau was born and where he briefly returned in 1709, was a frontier town and he may have witnessed military activity there. Whether he witnessed a mixture of the elegant and the mundane, as shown here, is unknown.

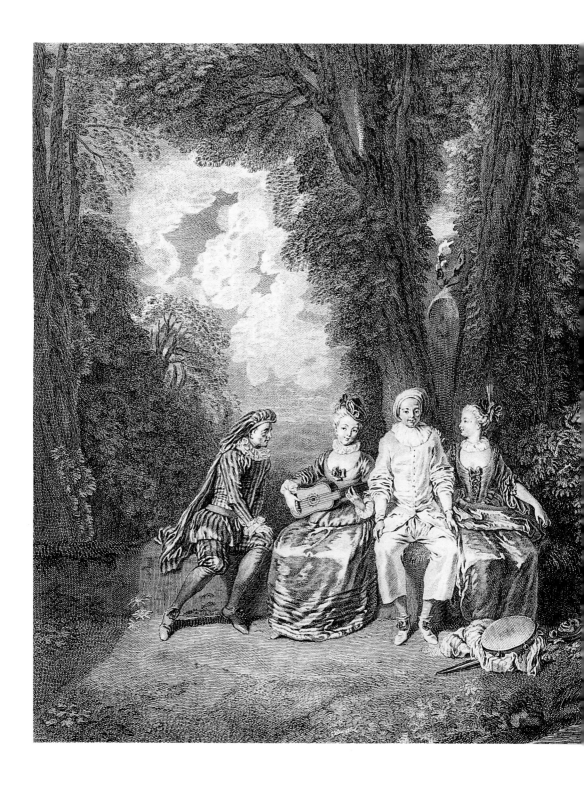

Watteau and the Académie

I n 1765 Dandré-Bardon wrote: "Watteau distinguished himself as much by his straightforward and elegant compositions as by a pleasant and mannered style. His genre, too alluring, too much imitated, would have been prejudicial to the essential parts of painting, if the Royal Academy [of Painting], always concerned with the general good, had not made provision for the matter...." What was the provision which the Academy made, and why did it feel the need to do so? After he had won his second prize at the Academy in 1709, there is no note of Watteau in its records until 1712. Then on July 30 of that year Watteau was provisionally elected a member subject only to the usual condition of submitting a reception piece. Unusually, however, instead of the subject being specified, Watteau was to be permitted to paint what he liked. To have achieved this provisional election, which marked an official recognition of his talent, Watteau had submitted some of his paintings to the Academy's members for scrutiny. Among these was a lost painting, *Les Jaloux*, known now through a print after it (**15**).

To understand why this painting presented the Academy with a difficulty, one needs to understand what one of its principal functions

15 After Watteau
Les Jaloux (**Made jealous**)
Engraving by Scotin
The original painting, now lost, was one of those which Watteau presented to the Academy in 1712 as proof of competence. It seems to have struck a chord with the art-buying public since numerous copies were recorded and one biographer claims that everyone rushed to have one of Watteau's works.

was. Academic training was designed to produce painters who could translate literary texts into visual terms, that is to say, to tell a story in paint. The careful study of human attitudes and expressions, and their subsequent depiction in a painting, would enable the viewer to recognize the subject matter and, figure by figure, to "read" the actions and emotions depicted. Gillot's theater scenes, although taken from burlesque comedy and not from more elevated texts such as the Bible or Virgil, did not depart from this principle. Watteau's *Les Jaloux*, however, is not based on a specific scene from a specific play. It contains no necessary consequence or moral. To be sure, all the characters are from the Commedia dell'Arte: Mezzetin looking toward the girl with the guitar, Pierrot in the center, and in the background in attitudes of surprise Scaramouche and Harlequin.

Thus, we may detect jealousy on the part of Mezzetin at the guileless pleasure of Pierrot. And half hidden are a satyr term and a sphinx, symbols of lust. Watteau has therefore created a series of allusions. Instead of the traditional type of painting which provided the viewer with a completed text, Watteau has given his viewers, as it were, a part-formulated question. Watteau was creating a type of painting without a subject, and the Academy must therefore have realized the futility of its specifying a subject matter for his reception piece.

Over the following years Watteau painted a large number of Commedia dell'Arte scenes, as well as so called "*fêtes galantes*", or scenes of social gatherings of elegant people—some in theatrical dress—in an outdoor setting. They often share the quality of evoking a mood rather than depicting an event, and of confusing reality and fantasy. In *Voulez-vous triompher des belles?* (**16**) are the figures actors and, if so, are they necessarily feigning their emotions? Such questions permit no definite answer

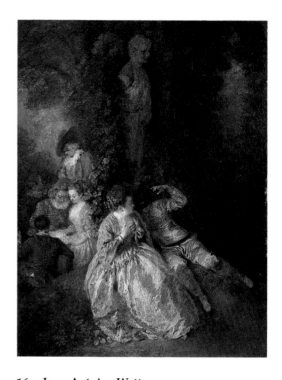

16 Jean-Antoine Watteau
Voulez-vous triompher des belles? (**Do you want to succeed with women?**)
Oil on canvas 36 × 25.9 cm
London, Wallace Collection
Like most of the titles of Watteau's paintings, this one derives from the title of the print made some years after his death.

Detail of 16

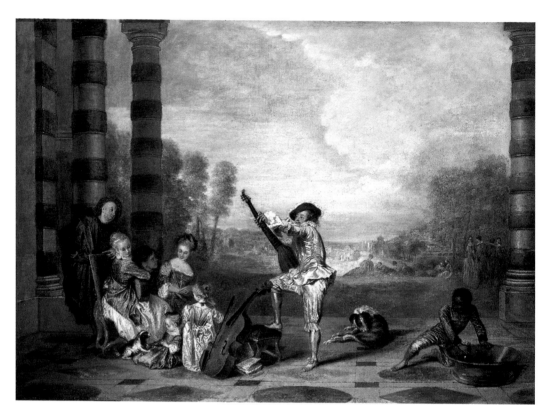

especially when we recall two circumstances. First, in the early eighteenth century, aristocratic amateurs began playing in their own versions of the Commedia dell'Arte's plays. Secondly, and more fundamentally, the Paris theater was not then simply a physical space where one watched professionals acting. It was also a social space, a place to see and be seen, to meet and see other theater-goers, even to the extent sometimes of parading on the stage. The members of the audience themselves thus created, and participated in, a kind of theater. So, where in the *fêtes galantes* and in the Commedia dell'Arte scenes Watteau mixes contemporary dress with theatrical costume, and uses other devices to confuse reality and fantasy, such confusion is itself anchored in reality.

Among these devices was the practice of

17 Jean-Antoine Watteau
Les Charmes de la Vie (The charms of life)
Oil on canvas, 67.3 × 92.5 cm
London, Wallace Collection

One of the criticisms levelled at Watteau later in the eighteenth century was of his reusing figures from one painting in others. The lutenist at the centre of this painting appears virtually unchanged in *Pour nous prouver que cette belle...* (Wallace Collection London,) and in *Le Prélude au concert* (Berlin, Charlottenburg). The little girl and the cello also appear in the latter. Watteau later re-used the dog, borrowed from Rubens, in *L'Enseigne de Gersaint* (36).

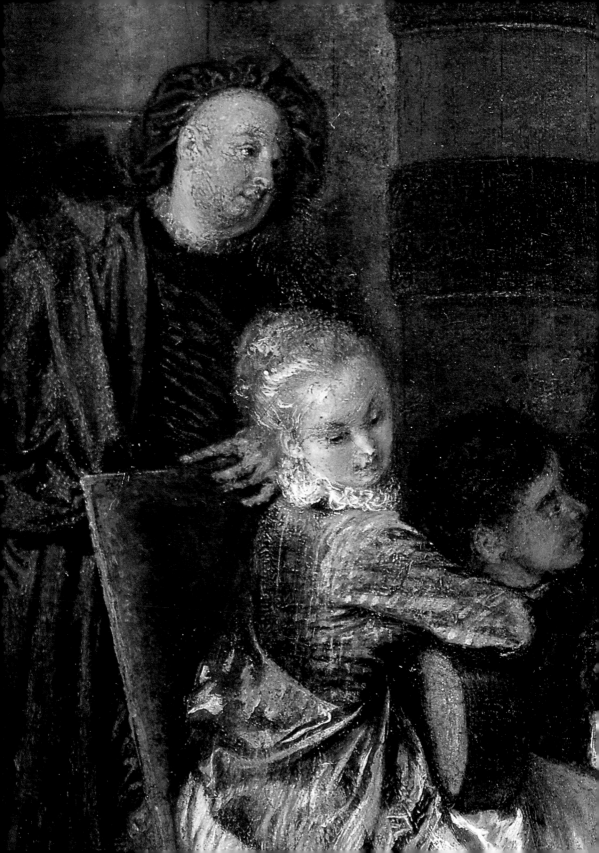

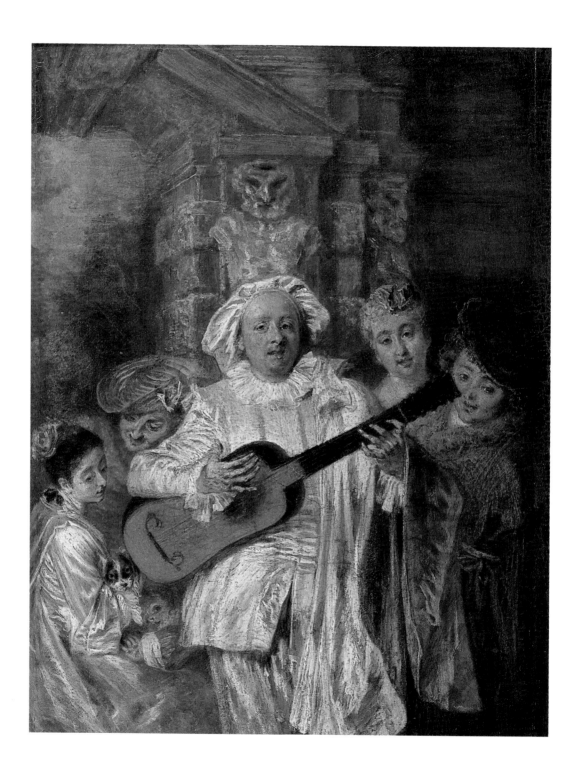

including portraits of real personalities among the imagined figures in his painting. Watteau's artist friend Nicholas Vleughels (1668–1739) is shown at the extreme left of *Les Charmes de la vie* (**17**), and again in the same position in *Fêtes vénitiennes* (National Galleries of Scotland, Edinburgh), while the dealer Pierre Sirois and members of his family appear in *Sous un Habit de Mezzetin* (**18**).

Furthermore, the settings of these scenes frequently contained ambiguities. In *Les Charmes de la vie*, for example, is the background meant to be real space or a theater backdrop? In *Voulez-vous triompher des belles?* (**16**) the group at the left appears far away from the central group, but in fact they are only separated by a small grassy bank. It is as if Watteau were saying that whatever the apparent distance between chaste love on the one hand and blatant lust on the other, in reality there was little to separate them. Only once is Watteau known to have used a real setting in a *fête galante*. In *La Perspective* (**19**) the scene is shown in the garden of Pierre Crozat's house at Montmorency, but the costumes are again a mixture of the real and fantastic.

Watteau's *fêtes galantes* are, then, distinct from their Northern predecessors, such as the *Garden party* by Dirck Hals (1591–1656) (**20**), and from prints of contemporary society by such as Bernard Picart (1673–1733). With Watteau time and place are unspecific. The figures interact psychologically but often only with a glance or a turn of the head and a veiled expression which gives little away.

From the point of view of academic painting, whose adherents were brought up to copy prints showing schematically a large number of different emotional states, Watteau's friend, the comte de Caylus, was right to complain to the Academy in 1748 that few of his paintings contained any action or emotion. Nevertheless, the emotional states

18 Jean-Antonie Watteau
Sous un Habit de Mezzetin (Portrait in disguise)
Oil on canvas, 27.7 × 21 cm
London, Wallace Collection

The painting represents the dealer Sirois and members of his family. The guitar is of a type usual in the period. In his *Traité d'Accompagnement* (1716) Campion wrote that of all instruments the guitar was most able to be emotionally affective. The architecture is taken from Rubens's *Garden of love* (**25**) of which there was a print in the eighteenth century.

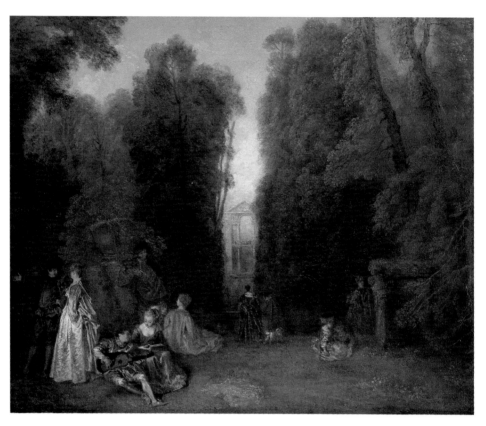

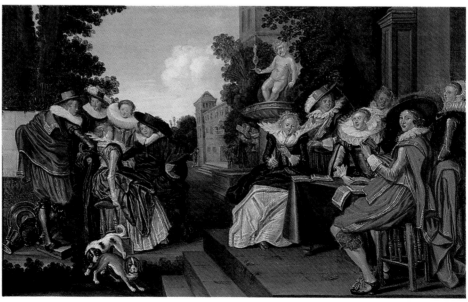

19 Jean-Antoine Watteau
La Perspective (The prospect)

Oil on canvas 46.7 × 55.3 cm
Boston, Museum of Fine Arts

The work was painted
around 1714. Although the
scene is based on the
garden of Crozat's house
at Montmorency, Watteau
has probably shown it
more overgrown that it
was. The façade of the
house in the background
therefore appears as a
kind of vision suggestive
both of an ideal place and
of another time.

Detail of 19

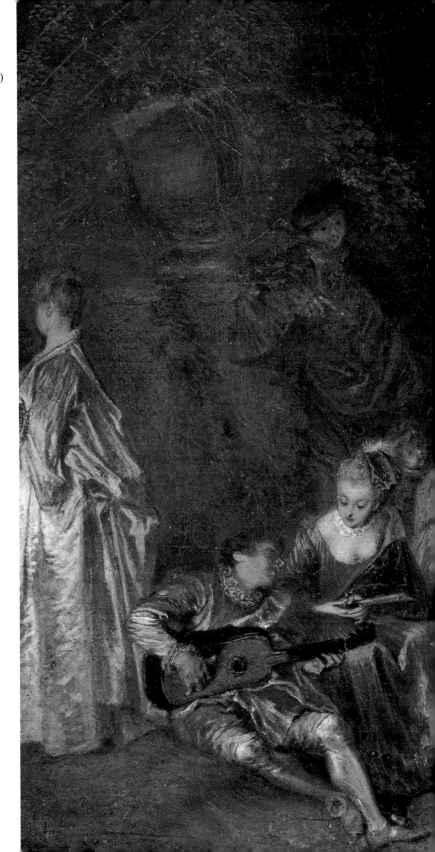

20 Dirck Hals
The garden party

Oil on canvas, 37.5 × 55.5 cm
Haarlem, Frans Hals Museum

Hals's painting, like the
fêtes galantes of Watteau,
combine the themes of
music and gallantry in a
pleasant outdoor setting.
The participants are all in
contemporary dress; there
is neither mystery nor
depth to the participants'
emotions.

Detail of 17 Jean-Antoine Watteau,
Les Charmes de la vie
Nearly one in three of Watteau's works show music being sung or played. Home concerts were popular with the wealthier citizens of the period, including Watteau's patron, Pierre Crozat, and music was an important element in the theater. Watteau knew a number of amateur and professional musicians and studied musical instruments carefully. A drawn study for the seated guitarist is in the Louvre.

of the participants of Watteau's *fêtes galantes* are often indirectly alluded to in still-life details of the statues or musical instruments. For example, the lute was known to be an exceptionally difficult instrument to tune, so that the lutenist trying to tune his instrument in *Les Charmes de la vie* (**17**) may be seen as trying with difficulty to start up a gallant conversation. His difficulties give time for another man to attract the attention of the woman nearest to the lutenist. This is a more subtle and delicate use of still-life symbolism than was used by Dutch seventeenth-century artists or, indeed, by Watteau himself in *L'Indiscret* (**4**). In *Les Champs Elysées* (London, Wallace Collection), Watteau has used a statue of a sleeping nymph—painted as if the stone were "alive"—to symbolize dormant desire, whereas in *Leçon d'amour* (Stockholm, Nationalmuseum), the statue of a rather less refined nude is sitting up and awake: desire has been aroused.

Watteau's *fêtes galantes* were sophisticated. Although not representing the elevated stories of antiquity, they could not be dismissed as simply as the rambunctious peasant scenes of Teniers or Ostade might have been. The open-endedness of their subject matter and their allusive way of suggesting emotional states subverted academic convention. They were inimical to academic art in another way. Beyond matters of style and technique and subject matter, all of which could to a degree be imitated, the power of Watteau's *fêtes galantes* lay in their psychological suggestiveness, and this was inimitable. His art could not be taught in any programmatic way, and teaching was the Academy's *raison d'être*. It would have been thoughts such as these which underlay Dandré-Bardon's comment that Watteau's art was prejudicial to the essential parts of painting, and it was such thoughts, not yet articulated in print, which probably

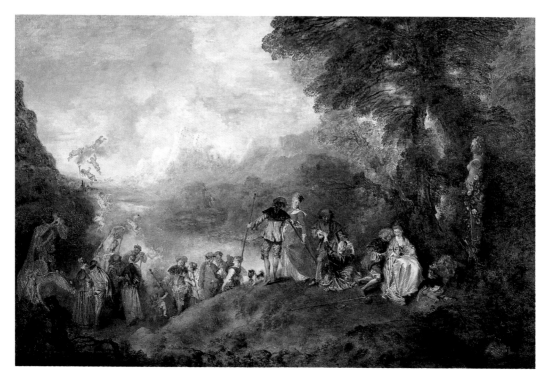

underlay the Academy's response to Watteau's reception piece when on August 28, 1717, following four reminders to the artist, it was finally presented to the Academy. Significantly, when the Academy recorded Watteau's election to full membership it first of all recorded receipt of Watteau's reception piece by its title, *Le Pèlerinage à L'Isle de Cithère* (The pilgrimage to the Isle of Cythera) (**21**), and then replaced those words with the words *"une feste galante"*. The Academy thus refused Watteau its highest ranking of membership, that of history painter, which might have led to his becoming one of its professors, but was obliged to recognize the *fête galante* as an entirely new genre.

The non-specificity of Watteau's *fêtes galantes* generally applies with particular force to *Le Pèlerinage*, giving rise, for instance, to the question of a recent commentator, namely whether the pilgrims are going to the island or

21 Jean-Antoine Watteau
Le Pèlerinage à l'Isle de Cithère (Pilgrimage to Cythera)
Oil on canvas, 129 × 194 cm
Paris, Louvre

Presented to the Academy in August 1717, this is one of the few paintings by Watteau which can be firmly dated as well as one of the few to be universally admired. A year or so later Watteau painted another version with a number of variations, now at the Charlottenburg, Berlin. Below the crest of the hill are couples in union. At the right of the painting, watched over by a bust of Venus, are three couples in various stages of progress to union. The early stages of courtship are shown at the extreme right. The amorous proposal is accepted by the girl in the central group, but, even as she prepares to descend the hill, the girl at the left seems both uncertain and to hope that her companions will follow.

Detail of 21

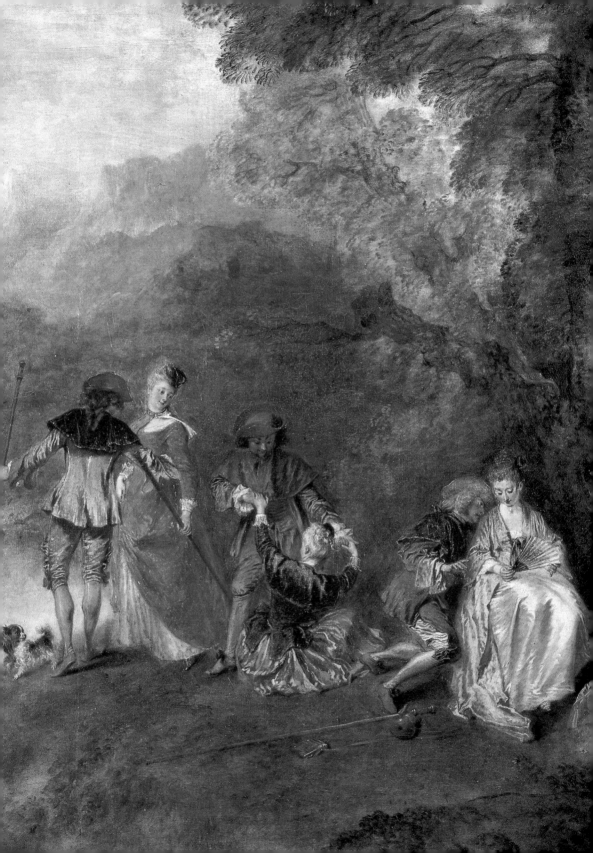

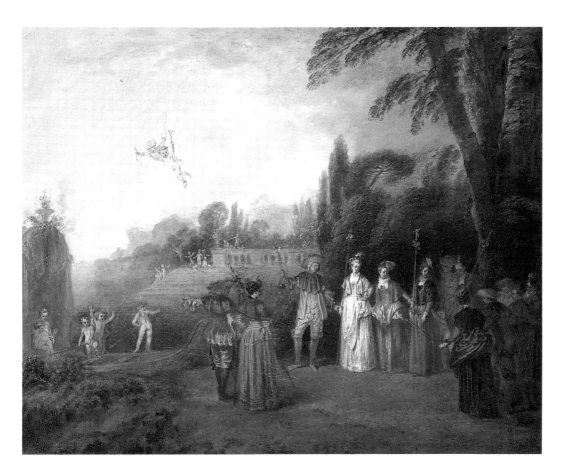

22 Jean-Antoine Watteau
Study for *Le Pèlerinage à l'Isle de Cithère*
Drawing, red black and white chalks, 33.6 × 22.6 cm
London, British Museum

The number of surviving drawings which relate
specifically to Watteau's reception piece attest
to its importance to him. In this study for the
central couples of the three at the right of the
painting, Watteau drew the figures first in red
chalk and then used black chalk to emphasize
certain features. White chalk has been applied
to indicate highlights.

23 Jean-Antoine Watteau
L'Isle de Cithère (The Island of Cythera)
Oil on canvas, 43.1 × 53.3 cm
Frankfurt, Städelsches Kunstinstitut

This was probably painted around 1709–10, and
possibly was inspired by Dancourt's comedy
Les Trois Cousines, which played at the Comédie
Française in 1709. In the last scene of the play
the young men and women of the village,
dressed as pilgrims, make ready to go on a
pilgrimage to the temple of love. These have
been identified in a number of other plays,
however, which may have been Watteau's
literary source. One of the women being
pushed toward embarkation was borrowed
from Rubens's *Garden of love* (25).

leaving it. Cythera was the mythical island of love, and depending upon whether the pilgrims were arriving or leaving, they might have been expected to look expectant or sated. But Watteau's pilgrims give no clue, and his painting could not be measured against the standard criteria for history painting of gesture and expression.

Watteau's subversion of academic criteria was peculiarly his own, but the theme of *Le Pèlerinage* was not. This had become common in plays from around 1713. Watteau had himself painted an *Island of Cythera* around 1709–10 (**23**) but not the voyage. For his reception piece he probably had recourse to an engraving of about 1708 by Bernard Picart. The open brushwork and broken color is derived from sixteenth-century Venetian art. The organization of the landscape is ultimately dependent on that of sixteenth-century Northern landscape painting with its high vantage point, the ground dropping away steeply to a distant view, and its coloristic division into brown, green, and blue to indicate recession. The more immediate influence, however, was the drawn landscapes then attributed to the Venetian artists Titian and Domenico Campagnola, themselves dependent on Netherlandish examples.

Watteau's interest in landscape had been stimulated by his introduction some time after 1711 to the wealthy banker and art collector

24 Jean-Antoine Watteau
Musicians seated under a tree
Drawing, red chalk, 19.2 × 25.8 cm
Besançon, Musée des Beaux-Arts et d'Archéologie
Watteau is said to have copied all the landscape drawings of the Venetian artist Domenico Campagnola (1500–64) in Pierre Crozat's collection. The buildings in the background of *Leçon d'amour* (Stockholm, Nationalmuseum) are similar to those in this drawing.

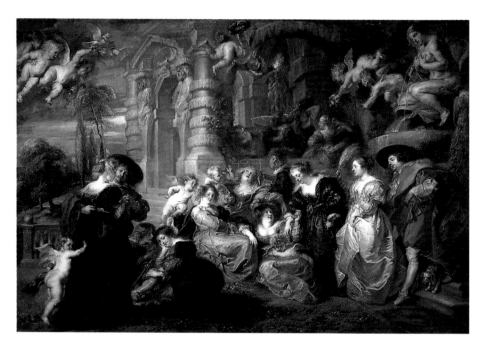

25 Peter Paul Rubens
The Garden of love
Oil on canvas, 198 × 283 cm
Madrid, Prado

The painting was described in Rubens's inventory as *Conversation of young women*. Thematically similar to Watteau's *Le Pèlerinage à l'Isle de Cithère* (21) and also using sculpted imagery to express ideas, Rubens's painting differs in its use of contemporary dress. Moreover the peacock at the extreme right, the symbol of Juno, goddess of marriage, binds Rubens's fantasy to a more prosaic world.

26 After Watteau
Triumph of Ceres
Engraving by L. Crépy

Ceres was the ancient Greek goddess of agriculture. Although Watteau's painting (now lost) is of a mythological subject, it may be more connected to the contemporary theater, possibly to a ballet, *Les Fêtes de l'Été*, produced in 1716.

Pierre Crozat (1665–1740). According to the comte de Caylus, it was among Crozat's extensive collection of drawings and prints that Watteau found landscapes of Titian and Campagnola, which he copied (24). In terms of Watteau's artistic development the connection with Crozat was important for two other reasons. First, Crozat's collection included a number of sketches by Rubens. Most of Watteau's copies are copies after Rubens or sixteenth-century Venetian artists. The art of Rubens provided a source for specific motifs and for figural relationships. For example, the dog in Rubens's *Coronation of Marie de Médici* appears in *Les Charmes de la vie* (36) and again in *L'Enseigne de Gersaint* (17); the architecture of the portico in *Sous un Habit de Mezzetin* (18) derives from that in Rubens's *Garden of Love* (25); and Watteau copied the embracing couple in Rubens's *Kermesse* to practice rendering human forms in a three-dimensional relationship.

Secondly, Watteau came into contact with the history paintings and prints by or after the Italian old masters in the Crozat collection. It was possibly the ageing painter, Charles de La Fosse (1636–1716), who worked for Crozat, who encouraged Watteau to look at them. Certainly, the dancing girl with the cymbal at the right of Watteau's now lost *Triumph of Ceres*, known through an engraving, (26) is an almost direct quotation from Annibale Carracci's *Triumph of Bacchus* in the Farnese Palace, Rome. We have seen that his *Diane au bain* (6) borrows a figure from *Diana and her companions* by the French academic painter Louis de Boullongne the Younger. Perhaps most important of all, Watteau was commissioned by Crozat to paint four large pictures of the Seasons for the dining room of his Paris house. Of the four only one, *Summer* (27), now survives, and another, *Spring*, recently destroyed, is known through a photograph (28). *Autumn*

27 Jean-Antoine Watteau
Summer
Oil on canvas, 142 × 115.7 cm
Washington, National Gallery of Art

Possibly this was painted after a design by Charles de La Fosse. In any event
the lion is taken from a painting by La Fosse of *God the Father* (Dunkirk,
Musée des Beaux-Arts).

28 Jean-Antoine Watteau
Spring
Oil on canvas, 119 × 98 cm after being cut down
Destroyed in 1966

There exist in the Louvre two drawings by La Fosse of the wedded pair: Zephyr, the west wind, and Flora, goddess of flowers. These were presumably preliminary designs for Crozat's commission, but Watteau substantially modified them. In doing so, he mastered the human form and perfectly integrated his composition within the oval frame.

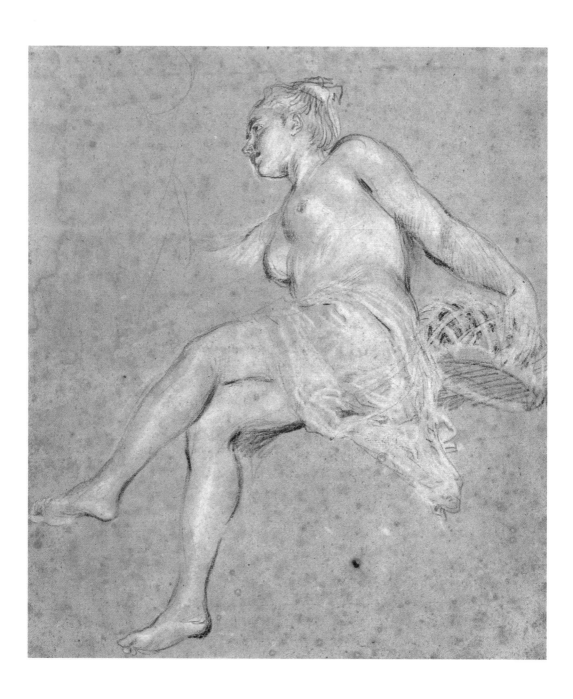

and *Winter* are known only through prints.

Crozat's commission of around 1715 required Watteau to undertake a number of academic figure studies of the nude model. In these he used his characteristic *"trois crayons"* technique of red, white, and black chalks (**29**), a technique which had also been used by Rubens and de La Fosse. Additionally, however, Watteau was required to create compositions which would harmonize with the oval frames of Crozat's decorative scheme, something which he brilliantly succeeded in doing in *Spring*. The *Seasons* were qualitatively different from the Audran type of interior decoration which Watteau had been carrying out: the figures were much larger in scale; two or more had to be combined convincingly in fictive space; and they were within the tradition of history painting and were therefore likely to be more closely scrutinized by Crozat's knowledgeable visitors than were playful arabesques.

It is not known why Watteau received no further commissions for history painting. Perhaps his *Seasons* were poorly received, since in his 1748 lecture to the Academy Caylus referred to their dry and mannered style. Perhaps Watteau found this type of work not to his taste, especially without the encouragement of de La Fosse, who died in 1716 and who, according to Caylus, had prepared the designs for the *Seasons* from which Watteau worked. Perhaps the demand for his *fêtes galantes* left Watteau too little time for more ambitious projects. Nevertheless, what emerged—probably from Watteau's work on the *Seasons* — was a then novel conception of the female nude in Western painting. Notice of this is already given in *Spring* where the figure and pose of Flora is based on that of the model drawn by Watteau (**29**). Instead of classicizing the model's features, Watteau has altered them to those of a contemporary nymph. By

29 Jean-Antoine Watteau
Study for *Flora*
Drawing, red, black and white chalks, 32.6 × 28.3 cm
Paris, Louvre
Watteau here adopts a drawing style appropriate for an academic subject and far removed from the puppet-like forms he drew when influenced by Gillot. The drawing once belonged to Edmond and Jules Goncourt whose writings in the mid-nineteenth century did much to revive Watteau's popularity with collectors.

30 Jean-Antoine Watteau
Nymph and satyr, also called *Jupiter and Antiope*
Oil on canvas, 73.5 × 107.5 cm
Paris, Louvre

The picture was painted around 1716. The figure of the satyr was based on one of Van Dyck's executioners in his *Carrying of the Cross* at the church of St. Paul, Antwerp; that of the nymph derived from a Hellenistic statue of a *Sleeping Eros*, which was known through many copies. The nymph was transformed into one of Watteau's "living statues" in *Les Champs Elysées* (London, Wallace Collection).

not distancing the female nude from the viewer's sense of reality, Watteau reduced its power as allegory while at the same time increasing its power for visual seduction. This process is made more explicit in the roughly contemporary *Nymph and satyr*, also called *Jupiter and Antiope* (**30**), where the unclassical features of the nymph bring her into our space temporally, just as her pale flesh, contrasted with the somber tones surrounding her, bring her into our space physically. These works nevertheless remain within the bounds of artistic tradition in terms of subject matter. They also remain within the bounds of the convention which required the nude to be some historic figure or to have some allegorical or moral function.

In Watteau's *La Toilette* (**31**), however, the woman removing her chemise may be taken as a metaphor for the removal of this social pretence, and as she looks directly at us, Watteau questions the nature of our gaze. Just as the daring concept of the painting emerged from *Spring*, so did its formal qualities: the oval of the frame is echoed by a series of oval shapes—the maid's bonnet, the woman's face, the shape made by her arms, and the line of her upraised arm and back. Watteau's *La Toilette* stands at the beginning of a substantial number of female nudes painted in France during the eighteenth century. It is not possible to tell to what extent this development was influenced by Watteau—few works like this by him survive. Perhaps the consummate formal qualities of the painting were seen to give a measure of respectability, permitting its emulation by later artists.

31 Jean-Antoine Watteau
La Toilette (**A lady at her toilet**)
Oil on canvas, 45.2 × 37.8 cm
London, Wallace Collection
This is one of the most celebrated of Watteau's works both for its compositional qualities and for its color harmonies. It was probably painted around 1716–17. The cupid's head and scallop shell at the head of the bed allude to Venus, but the mythological reference is negated by the maid's presence, which makes the nude an entirely contemporary figure.

Detail of 31

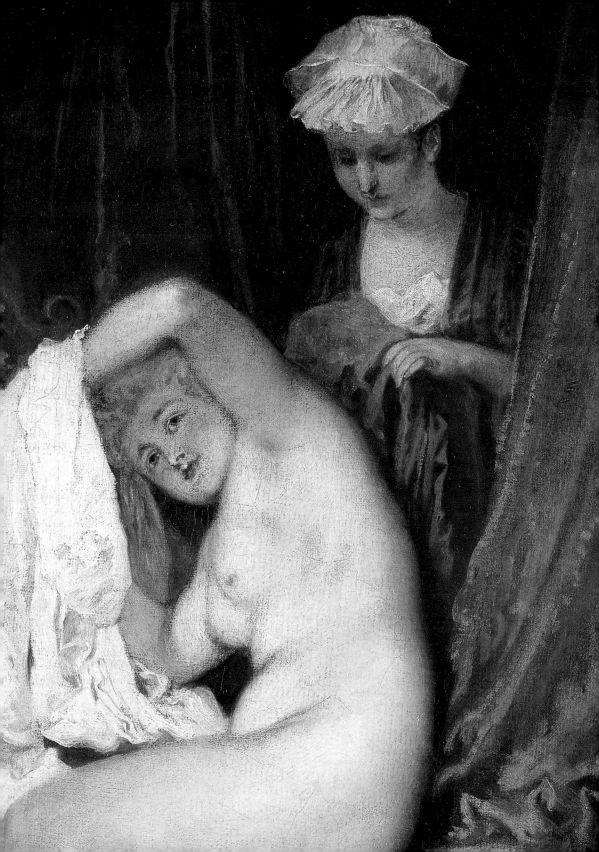

The last years,
1718–21

The period began brightly enough for Watteau. In a biography written in 1726 Jean de Jullienne relates how in 1718 Watteau's reputation was at its height: he had, we are told, several important people among his friends and he could have been advantageously placed if only he had stayed in Paris. Snippets of surviving correspondence confirm Julienne's assessment. At the end of 1716 Crozat wrote to the celebrated Venetian painter of pastel portraits, Rosalba Carriera (1675–1757): "Among all our painters, I know only Monsieur Watteau as capable of making some work which is worth showing you. He is a young man to whose home I have taken Sebastiano Ricci [another well known Venetian painter]. If he has a fault, it's that he takes a very long time doing anything." Around the beginning of 1719 the First Painter to the King of Prussia, Antoine Pesne (1683–1757), wrote from Berlin to the Paris painter Nicholas Vleughels (1668–1737), for advice on the composition of Pesne's reception piece for the Academy in Paris. "Show [the enclosed drawing] to Monsieur Watteau as well," wrote Pesne. "He has thoughts which I don't have and will express them frankly." It was also in 1719 that the first brief biographical notice on Watteau appeared. This was in Father Orlandi's *Abecedario pittorio*, an "ABC of Painters," which Orlandi dedicated to Crozat.

In spite of these signs of success, Watteau was in London by the end of that year, although no precise departure date is known. What prompted this journey? Part of the reason was probably restlessness, an aspect of Watteau's personality which a number of his early biographers noted. Watteau had gone

32 Jean-Antoine Watteau
Portrait of a gentleman
Oil on canvas, 130 × 97 cm
Paris, Louvre

The identity of the sitter is unknown. Probably painted around 1718, this is the only known conventional portrait in Watteau's œuvre. Watteau painted his friend La Roque in a woodland setting with nymphs and satyrs, and a self-portrait with Jean de Jullienne in a glade with instruments of painting and music. Other friends were portrayed as comic actors in theater scenes.

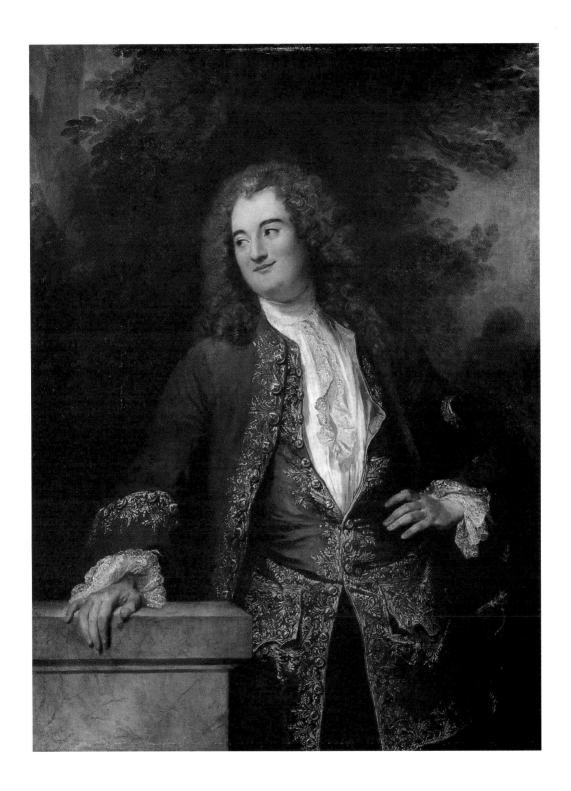

to stay at Crozat's house for a period in 1717–18, then for a time during 1718–19 had shared lodgings with Vleughels, and in the last year of his life he moved at least twice after his return to Paris. Horace Walpole, writing later in the eighteenth century, claimed that Watteau went to England to consult the well known English doctor, Richard Mead (1673–1754), but Mead specialized in infectious diseases such as smallpox and not in tuberculosis from which Watteau suffered. Possibly Watteau went to England to earn money. There was then an expanding market for art in England with insufficient domestic talent to satisfy it. Watteau painted two pictures for Mead, who was as well known as a collector as he was as a doctor. His biographers noted that on his return to Paris Watteau was keen to make money—this, however, may have been because in 1720 during his stay in England he had lost money when the Banque de France crashed.

Yet another possibility is that he had reached a personal crisis as an artist. His production of fêtes galantes tailed off after 1718. Perhaps after the supreme effort of Le Pèlerinage à l'Isle de Cithère, and of the second version which he painted soon after (now at the Charlottenburg in Berlin), he felt that the fête galante as a genre was played out. He certainly had cause to worry about its ceasing to be original. It is not known when Watteau's former colleague in Gillot's studio, Nicolas Lancret (1690–1743), publicly exhibited two paintings so much in Watteau's style that several of his friends congratulated the older painter on them. Watteau was sufficiently annoyed by this plagiarism never again to speak cordially to Lancret.

More alarming from Watteau's point of view was that in March 1719 Lancret was admitted to the Academy as a painter of fêtes galantes. His enemy and imitator was therefore in the Academy's eyes on a par with him, the originator of the genre. This external threat, combined with a certain ambivalence toward fêtes galantes, may have been the factors behind both Watteau's change of residence and the new directions which his art began to take. One must date his few portraits to this period of his life, including the Portrait of a gentleman in the Louvre (32), and the so called Iris c'est de bonne heure (33). The latter was probably painted in England. It is also to around 1718–19 that one must date Watteau's haunting Pierrot or Gilles (34).

This last painting, unusually large by Watteau's standards, was possibly executed as a shop sign for the café which the celebrated actor Belloni (c1680–1721) opened on his retirement from the stage. While the perspectival ambiguity of the space behind the central figure is common enough in Watteau's paintings, one is struck by the monumentality of the central figure itself. Its size relative to the area of the painting, the frontality of the pose and the directness of the look give it a dominating presence. Its expression gives little away. While the subsidiary figures, which may also be portraits of people in Commedia dell'Arte costumes, are engaged in dragging an ass across the "stage," Pierrot stands with both his body and face immobile. If the painting is indeed a portrait, then Watteau had conceived Belloni as an actor more intelligent than the role of the naïve Pierrot in which he is shown.

Les Comédiens Italiens (35), datable 1719–20, and possibly a group portrait, is remarkable in a number of respects when compared to Watteau's pre-1719 work. It is classically composed with the figures ranged across the picture plane. The figures are more convincingly defined within real space here than in previous works. The architecture and parkland view behind them have more of the

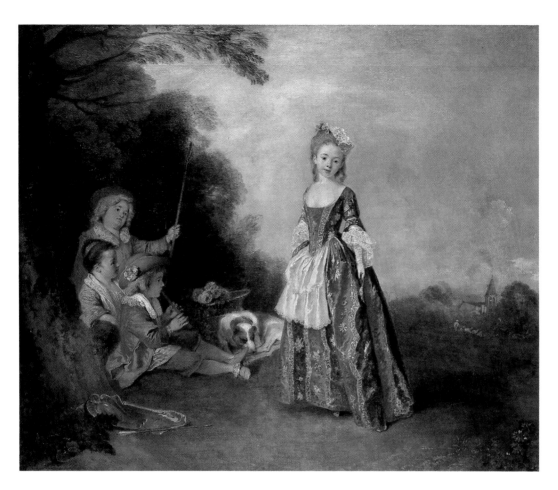

33 Jean-Antoine Watteau
Iris c'est de bonne heure (It is too early to dance)

Oil on canvas, 97 × 116 cm, possibly after enlargement from a circular
composition
Berlin-Dahlem, Staatliche Museen

The girl's costume makes it likely that this was painted in
1719–20 during Watteau's stay in England, as a portrait in the
guise of a childish *fête champêtre*.

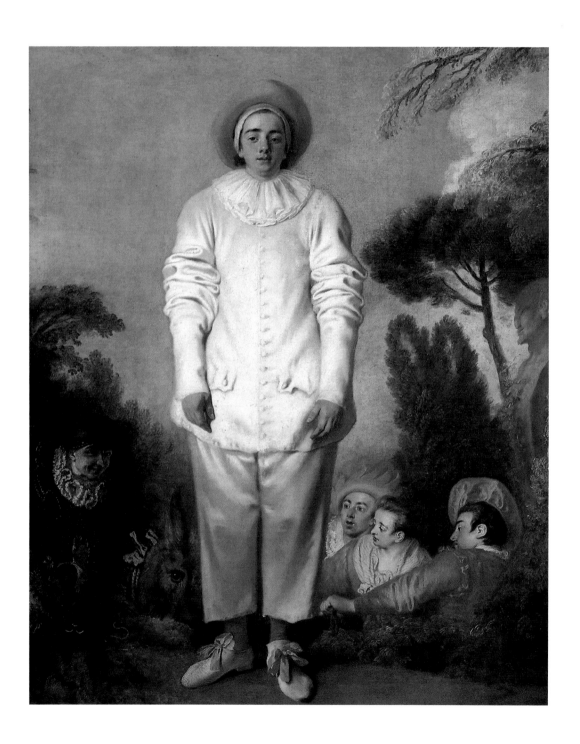

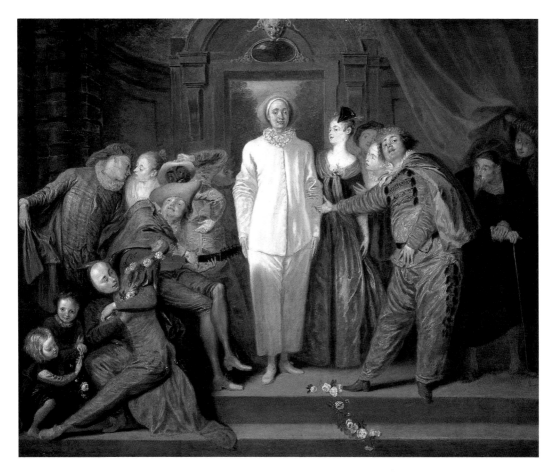

34 Jean-Antoine Watteau
Pierrot, also called *Gilles*
Oil on canvas, 184.5 × 149 cm
Paris, Louvre

This was probably painted around 1718,
apparently a portrait but the principal sitter's
identity is uncertain. It is the only painting by
Watteau with life-size figures. Besides Pierrot
at the center, the other theatrical figures are
Crispin riding an ass, the Captain at the
extreme right, and Isabella. The figure in the
coxcomb hat is unidentified. If it is correct that
Pierrot represents the actor Belloni, then it
seems probable that the other figures are also
portraits, whether of other actors or of friends
of Watteau.

35 Jean-Antoine Watteau
Les Comédiens Italiens (The Commedia
dell'Arte)
Oil on canvas, 63.8 × 76.2 cm
Washington, National Gallery of Art

This was painted in England in 1719–20 for
Dr Richard Mead. According to the *Mercure de
France* in 1733, the picture consisted almost
entirely of portraits of people "able in their
calling" whom Watteau painted in the different
costumes of actors of the Italian theater.

Overleaf: detail of 35, Jean Antoine Watteau,
Les Comédiens Italiens

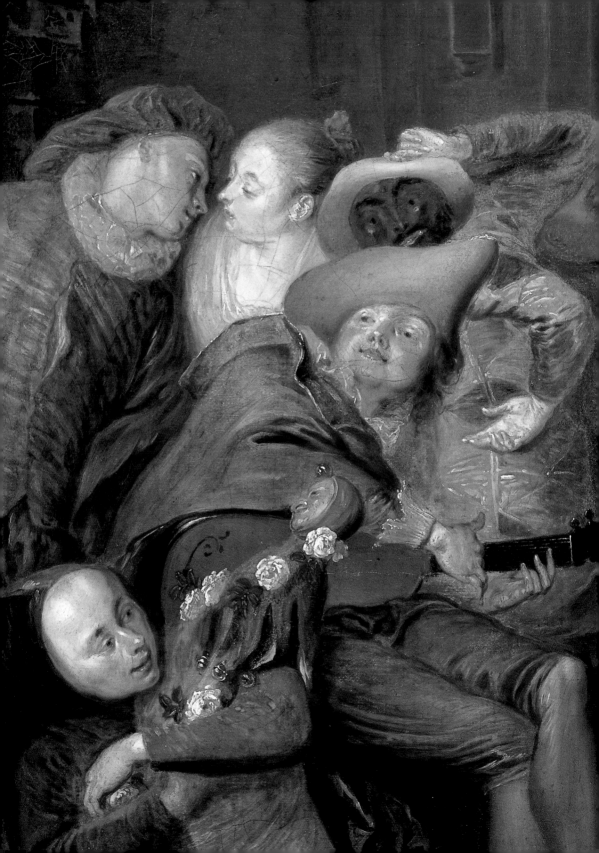

character of a theater backdrop than of reality, but this is consistent with the evident stage setting. Perhaps most unusual of all is the number of compositional drawings made by Watteau for this painting. Unless it is simply an accident of survival, they attest both to the great care which the artist took in its preparation and to a change in his working procedure. Whereas for the *fêtes galantes* Watteau usually first worked out his landscape background and then chose from pre-existing figures in his sketchbook, in *Les Comédiens Italiens* he seems to have been trying to work out the relations between the figures and the dispositions of the architecture from the beginning in an integrated way. There then followed a number of drawn studies for individual figures, heads, and hands. This would have been the approach also of an academic history painter, and one which Watteau seems to have adopted only rarely earlier in his career.

The date of Watteau's return to Paris from London is unknown, but it was certainly by August 1720 when Rosalba Carriera recorded a meeting with him in her diary. He went to live with the art-dealer Gersaint (1694–1750), who had his shop at the sign of the *Grand Monarque* on the Pont Notre-Dame, and who was the son-in-law of Pierre Sirois, the buyer of two of Watteau's military subjects some ten years earlier. It was for Gersaint that Watteau painted the *Enseigne de Gersaint* (**36**) which was placed briefly above the front of his shop before being removed to protect it from the weather.

The art historical literature on the *Enseigne*'s meaning is extensive. Many interpretations have been influenced by the fact that Watteau was ill from tuberculosis when he painted the *Enseigne* and died within a year thereafter. The *Enseigne* has therefore been seen as a symbol of passing time and of the vanity of earthly possessions, and one in which the fictive paintings at the back of the shop are said to represent Watteau's dying homage to past masters. There is, however, no evidence that Watteau believed himself to be dying. On the contrary, in early 1721, shortly after painting the *Enseigne*, he was engaged by Pierre Crozat on a long-term project to make drawings of Italian paintings in the major French collections with a view to their being engraved. What this suggests is that Watteau was about to embark on an extensive exploration of Roman and Bolognese painting to add to his existing knowledge of Venetian and Flemish sources.

If that is correct, it would confirm the view that Watteau was intending to explore new possibilities for his art. What, however, of the *Enseigne* itself? After a year's absence in England Watteau probably saw in this large, publicly exhibited painting as much an advertisement for his own talents as for Gersaint's shop. As regards its meaning, stripping it of its supposed morbidity, we should see it perhaps just as ironic comment on the art-buying public: the kneeling gentleman who is studying the painting so minutely is really looking at the female nudes; the couple on the right adore their own reflections in the mirror, behind which Watteau has placed a painting of the Virgin and St. Joseph adoring the Christ Child as ironic commentary; above the head of the gentleman inviting the lady into the shop is a painting of a satyr chasing a nymph. Possibly only "true connoisseurs" of art would have recognized such allusions and appreciated their wit.

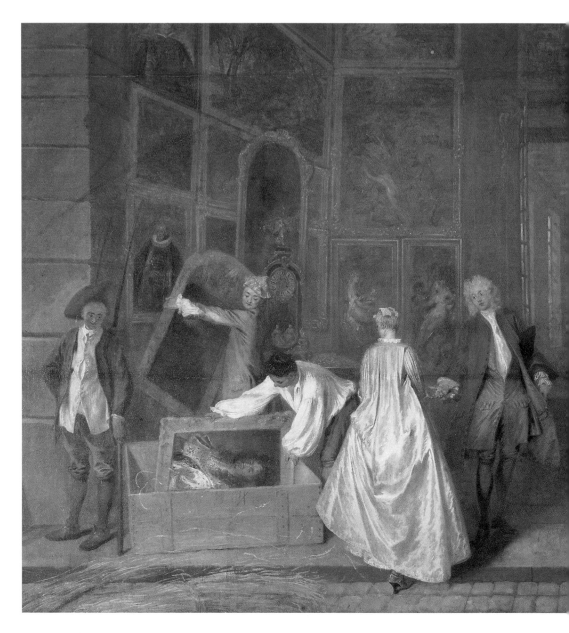

36 Jean-Antoine Watteau
L'Enseigne de Gersaint (Gersaint's signboard)
Oil on canvas, 166 × 306 cm
Berlin, Charlottenburg Palace

The largest of Watteau's paintings, this was originally wider and had an arched top to fit above the entrancce to Gersant's shop. Watteau painted it in two halves, and it may have been his pupil Pater who modified it to its present state.

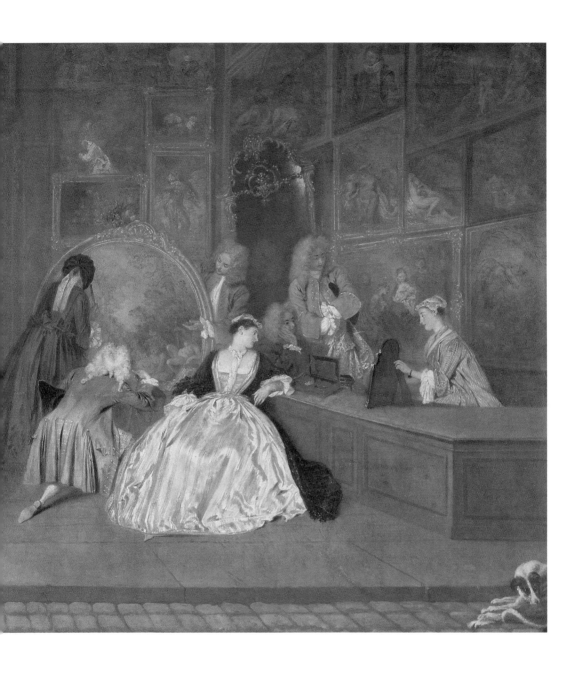

Watteau's influence

Watteau died on July 18, 1721 at Nogent-sur-Marne. According to Gersaint, Watteau died in his arms but before doing so instructed him to share his drawings between his four friends: Jullienne, Haranger, Henin, and Gersaint himself. In fact, most of them were left to abbé Haranger who had found Watteau his lodgings at Nogent. Perhaps the significance of Gersaint's account is in the way he measured Watteau's affections, namely in the sharing out of drawings. For by 1748, the date of Gersaint's account, Watteau's drawings were universally valued. Whereas, as we have seen, his painting attracted criticism (as much for shoddy technique as for anything else), particularly from academically inclined commentators like Caylus and Dandré-Bardon, his drawings (**37**) were seen by all to have an independent aesthetic value. Discussing Watteau's drawings the connoisseur Dezallier d'Agenville spoke of "the freedom of the hand, the lightness of touch, a subtlety in the profiles of heads and the drawings of hair, the expressiveness of the figures and compositions, the pervasive feeling of these drawings are in collectors' eyes unmistakably characteristic of Watteau."

The value of Watteau's drawings as aesthetic objects is shown by the fact that Jean de Jullienne's first volume of etchings reproducing the artist's works, *Les Figures de différents caractères* of 1726 and 1728, were of 351 drawings. It was probably unprecedented for the drawings of a painter to be so extensively reproduced. Their publication can be seen as both symptom and cause of the increasing appreciation of drawings by collectors. In 1727 Jullienne started to publish, one by one, engravings after Watteau's paintings. These were then published together as the *Recueil*

Jullienne in 1735. The *Recueil* serves now as a valuable source for Watteau's lost paintings, but in the decades following his death it must have helped to widen the taste for *fêtes galantes* as well as providing specific models

37 Jean-Antoine Watteau
Nude woman with right arm raised
Drawing, black and red chalk, 28.2 × 23.3 cm
Paris, Louvre
This drawing is not connected with any known composition, but it shows what the eighteenth-century connoisseur Dezallier d'Agenville called Watteau's "lightness of touch, a subtlety in the profiles of heads and the drawing of hair [and] the expressiveness of the figures."

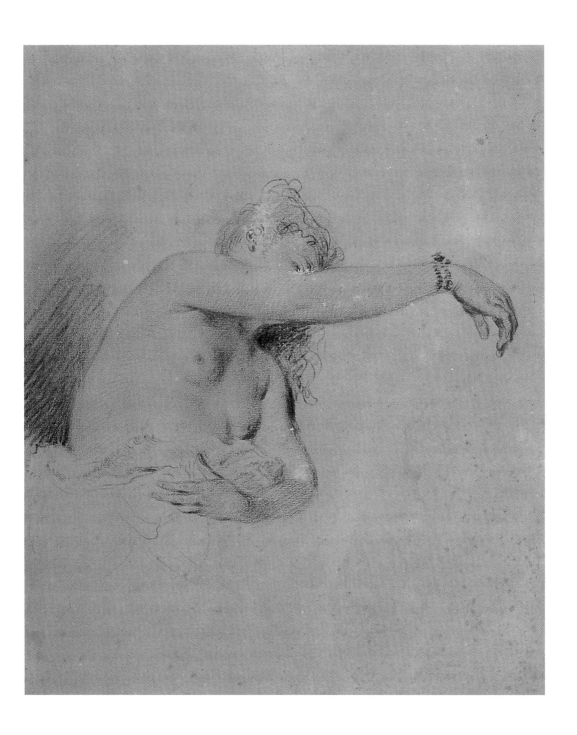

for future artists. Watteau's designs as derived from the *Recueil Jullienne* were extensively used in interior decoration in panelling and over doors. In some cases interior schemes using Watteau's designs were themselves reproduced, for example in Mariette's *Architecture Française*, thus further disseminating Watteau's influence.

Although taste in interior decoration panelling was changing in France in the 1760s, Watteau's designs were still being used at that time in houses in England and Germany, and for tapestries made in France and England. From the middle of the century his designs were also being used on French and German porcelain as well as on Delft faience, although never so extensively as those of Boucher.

With regard to painting itself, a taste for *fêtes galantes* broadly in the style of Watteau developed in the decades after his death and was satisfied in France by Lancret, Jean-Baptiste Pater (1695–1736) and others, and in England by Philippe Mercier (1689–1760). It was the multiplicity of images in the Watteau style created by artists of inferior talent which helped to undermine Watteau's reputation. François Boucher was not, of course, an inferior talent and as a young artist he had participated in making prints for Jullienne's *Figures de différents caractères*. Boucher made some direct borrowings from Watteau, but more importantly, his conception of gallantry as a subject appropriate even for a history painter is due to Watteau having created a visual language to depict erotic desire which was socially acceptable for display.

When the technique of printing to imitate the effect of chalk drawing was developed in the middle of the eighteenth century, Watteau's drawings were reproduced "*en manière de deux crayons.*" They were used by students to learn the effects of black and red chalks in their own exercises. It was from the 1750s, as we have seen, that Watteau's reputation began to suffer but, bearing in mind the universal admiration for his drawings, their use by students is not such a paradox as it may first appear.

Assessing the long-term influence of a single artist is inevitably problematic. Had Watteau's works not been so popular, had they not been widely imitated, disseminated via prints and used in the decoration of houses and on *objets d'art*, they would hardly have been likely to be the subject of controversy. The controversy arose, as expressed by Caylus and Dandré-Bardon, because Watteau subverted academic norms: attitude and expression were ambivalent; perspective was distorted; figures were repeated from one painting to another; nudes were nudes and not goddesses or biblical heroines; subjects, above all, were not precisely identifiable; images were suggestive rather than declamatory. Thus, one may see in the *Enseigne de Gersaint* melancholy, frivolity, irony, or each of these things, and doubtless others, at different times. Because Watteau's art is evocative, because its subject matter is open-ended, it can only be completed by the projections on to it of the viewer's imagination.

In this sense Watteau's ultimate influence was in helping the liberation of painting from text. He created an art which defied precise meaning and yet also demanded the viewer's participation in creating meaning. In doing so he promoted the visual over the verbal and made paintings constantly capable of being re-created anew in the mind of each viewer. Thus began a process of the reconditioning of our responses as viewers which now enables us to respond to paintings without intrinsic meaning. It may seem a long way to travel, but our appreciation of, say, the color fields of Mark Rothko (1903–70) has its origins in the art of Watteau.